Seeing Venice

© 2002 J. Paul Getty Trust

Getty Publications
1200 Getty Center Drive
Suite 500
Los Angeles, California 90049-1682
www.getty.edu

 Library of Congress Cataloging-in-
Publication Data

Doty, Mark.
 Seeing Venice : Bellotto's Grand Canal /
essay by Mark Doty.
 p. cm.
 ISBN 0-89236-658-3
 1. Bellotto, Bernardo, 1721-1780. Grand
Canal. 2. Bellotto, Bernardo, 1721-1780—
Criticism and interpretation. 3. Venice
(Italy)—In art. 4. Painting—California—Los
Angeles. 5. J. Paul Getty Museum. I. Title.
 ND623.B43 A64 2002

2002008910

PUBLISHER
Christopher Hudson

EDITOR IN CHIEF
Mark Greenberg

EDITOR
John Harris

DESIGNER
Hillary Sunenshine

PRODUCTION COORDINATOR
Stacy Miyagawa

PHOTOGRAPHER
Anthony Peres

The author is grateful to the Center for
Scholars and Writers at the New York
Public Library, whose generous support
made possible the writing of this essay.

Printed in Italy

Seeing Venice

BELLOTTO'S GRAND CANAL

Essay by Mark Doty

The J. Paul Getty Museum, Los Angeles

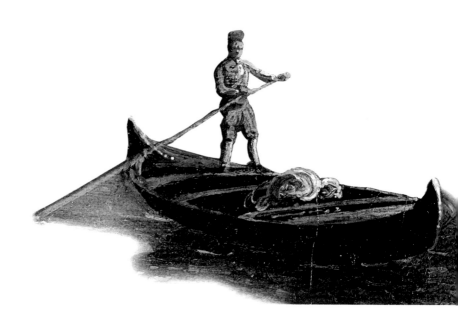

Seeing Venice: BELLOTTO'S GRAND CANAL

Mark Doty

PRIVACY *In* cities, paradoxically, there is an extraordinary kind of privacy; hurry and talk, just a little distance away, make solitude more complete, and more delicious. This man who's stepped out onto the balcony on the side of a grand house overlooking the canal, his face turned toward open water, this woman a floor below him, on a balcony of her own, three small stone creatures on her balustrade—they are caught in moments of contemplation. They're fixed in postures of ease; they have as much time as they like. She leans forward on her elbows, a piece of cloth—scarf, handkerchief, dustrag?—draped from the railing between her hands; he rests his right arm on the rail, his body inclined toward the view. Great expanses of sky open beside them, a continuum of atmosphere interrupted only by the jutting of masts, banners half-flying in the breeze. That wind seems to be blowing only in the marine distance. Here in town the air's utterly still, and clear. Huge field of sky relieved by cloud banks. So much space around the dreamers; their equivalents in the twentieth century would be the isolated figures of Edward Hopper, solitary citizens poised in perennial silence.

 Down below, on the ground floor, even the uniformed footman in his white stockings and powdered wig lazes against the doorframe. Nothing to do. Is he idly watching that shawled woman walk by? In truth he seems to pay her no attention at all. For this is the house of reverie, where no one stands up straight, and everyone seems lost in meditation, as if it were their work, and the city itself emerged from their dreaming.

SKY Greenery—leaf, tree trunk, flowers, scrap of weed poking from a stone wall or stray corner: there is none, not a drop. Everything here has been shaped by human hands. This is the built world raised to its highest power, even the water channeled, its path directed. And though the lowest reaches of the sky are cut with rooftops, the horizon pierced with masts and spires and domes, just above their highest peak the sky is free, unwritten.

Therefore the great presence of the natural here is the sky: magisterial, birdless, thrillingly vacant beside the crowded world of the town.

CONTRADICTIONS Adriatic weather, cool enough for people on the street to be cloaked and shawled, warm enough for the boatmen to work in shirtsleeves and for the woman daydreaming on her balcony to be comfortable in her décolletage. Spring, fall? No way to distinguish, not in this landscape. Do the clouds promise weather to come, or speak of turbulence passed? These boatmen, of course, would know precisely how to read them.

For us, they're form and surface, massed just to the left of the domes of the Salute, the great silvery church built to commemorate the end of the Plague. They seem themselves almost to be domes, or architecture, big distant billows, the atmosphere's admiring mirroring of Venice.

More accurate to say it's Venice that adores the sky, the airy panoply its richness and variety frames. The city of earth and water commingled turns its attention to a third element, the unstable palaces of air.

WATER An odd hardness about it, a flat, impermeable look. Glassy, impenetrable, as if it strove to be part of the world of pavement.

REFLECTION No accident that Venice is also a capital of glass: here the world's doubled, distorted, rippling—reflections almost freed from reference.

In fancy Venetian mirrors, an expanse of looking glass is framed by more mirror; we see ourselves looking back from every surface, every angle; the mirror takes pleasure in complicating, breaking apart, keeping us off kilter, afloat. That seems a goal of Venetian painting, too, at least of painters earlier than Bellotto: they want to upend us, with wild skies and troupes of suspended saints, and dizzy perspectives looking up into the nostrils of horses or the grand billow of Europa's draperies, into the robes of the Virgin as she flies skyward. The angel who hurtles through Mary's window in Tintoretto's *Annunciation*, the swirling array around his stolen body of Saint Mark, untroubled by gravity—they seem intended to keep us unmoored.

Bellotto's painting is more solidly positioned on earth, though his city is not only afloat but alive with intricate realms of detail, layer upon layer, one impression opening into another. I can stare and stare into it and never seem to reach the end.

His painting is itself a mirror, as indeed there are reflections of Venice all over the globe. Henry James: "Of all the cities in the world it is the easiest to visit without going there."

SHADOWS One of the qualities that distinguishes Bernardo Bellotto from his uncle Canaletto—the famous painter of views, many of them centered upon this same canal—is the younger man's interest in sharp, deep shadows, the drama added to the urban by buildings' interruption of light. Bellotto was nineteen when he painted this picture. Imagine the discipline required of such a young man, the years of practice necessary to make *this*. Trained in his uncle's studio, he must have been eager for ways to distinguish himself, to extend a profitable family enterprise *and* prove his own particular mettle.

Or perhaps he didn't have to try. Maybe it's simply that character emerges, on the canvas, inscribed by our individual ways of seeing. And so Bellotto's characteristic sense of silence and hardness, the blue cast to his light, the fascination with strong and angular shadows—do these just emerge spontaneously, having to do with the particular ways of seeing that were Bernardo's?

What are we purchasing, when we pay attention, but ourselves? Surely one thing character is is a style of seeing.

BLACK Any city has areas of impenetrability: closed rooms, doorways leading into shadow, protected or shielded zones. That box on the side of the house, with its pointed roof and its single door open to reveal a rectangle of pure darkness, is a sort of shrine, but in Bellotto's hands it seems almost abstract. The wall on which it hangs is rendered with such attention to the way light can arouse every inch of a complex surface that it might be a Dutch wall, a patch of Vermeer's little street scene. Or a magnified detail from his view of Delft, another town seen across water, another place lifted out of time, raised into the world of light, made permanent by the power of the artist's gaze linked to the materiality of oils, clays, tinctures, powders, bits of oxides and metals and gems.

This wall needs its small black rectangle, inside the box, to allow the sunwashed expanse to dazzle, to seem almost overexposed. There's a little bit of startle in that: the recognition that Bellotto knew exactly how it felt to be dazed by too much light, the sudden blinding look of a pale stone wall in summer. He felt precisely that physical sensation, and when we look at this little patch of wall, we feel it too—our bodies and his conjoined, across a gap of time wider and deeper than any canal.

WALL In my apartment in New York, there is a small bedroom the previous occupant lacquered a glossy chocolate brown, making the room into a sort of cave, a welcome respite from the city. The one window, uncurtained, opens onto a narrow breathing space between buildings; the brick wall which comprises my view is only two feet away. It's a rough wall, mortared to allow scallopings and eruptions of mortar between the flat, narrow bricks. These extrusions serve to catch the light. There is not a lot of light, but what there is arrives in constantly varied guises—silvery, muted, warming, crisp, articulate, chilly, weak—and the complexities of the surface allow all these qualities to be more fully expressed. The dark paint of the room and the severity of the view seem somehow an opportunity; they limit perception and yet reward with an intensity of sight. Which is the power of the detail: to crop and focus our vision, to bring the eye to rest on a singular spot so that we might understand the way in which every location might be equally loved.

SURFACES Ruskin: "The Venetian habitually incrusted his work with nacre; he built his houses, even his meanest, as if he has been a shellfish—roughly inside, mother-of-pearl on the surface."

INSTABILITY Reflection is never still; these palaces and spires melt into their own continuously troubled images. Of any capital that people have ever dreamed to build, this one is surely the most unstable; it smells everywhere of salt water and of varying degrees of decay. The tides pour in and out, and lap against the walls just on the outside of hotel rooms; it's easy, listening to waves against the walls in the dark, to think the whole island's rocking with the sea, barely moored. It seems a phantom; it calls up a phrase from Browning's sad Venetian poem: "These suspensions, these solutions . . ." Part of the world's love for this place must surely have to do with the fact that it has always seemed ephemeral, doomed. Might the whole city drift away? Certainly it might go under. It goes under already in the seasons of *aqua alta.* The plans advance for strange barriers in the lagoon, to block the rising waters of the world.

There is something moving simply in the idea of a painting of Venice; here is a liquid world represented with other liquids, the painter's minerals and oils doubling the city's world of mineral and water.

SOUVENIRS "There is nothing more to be said about it," wrote Henry James about Venice in 1882, before he went on to say a good deal. Before and since, a small canal's worth of ink has been spilled in the attempt to describe something of this place, not the least of it poured out by James himself. What is it about this liquid town that drives us to fix it, make it permanently part of ourselves?

In truth every traveler brings home something of it, a memento cast in the city's own image. Marbleized paper, with its patterns as complex as reflections on water. A bit of Murano glass, another liquid semblance, material which adds to the Venetian triumvirate of water, earth, and air the necessary fourth agent, the fierce annealing power of the furnace. Postcards; guidebooks; memory. In antique shops

and attics all over the planet are tokens of the place, paperweights and books of views, amateur sketches and watercolors and studies in oil.

Bellotto's own canvas, indeed, is an elegant, expensive souvenir, a token of the genius of the place to be carried home, probably to Northern Europe. By the beginning of the eighteenth century, Venice was no longer a great maritime power; instead, it drew moneyed tourists to carnivals, regattas, and festivals, and offered them the pleasures of two hundred restaurants and cafés, seven theaters, and an array of brothels and casinos. A capital of power had become a capital of pleasure, and the visitor wanted to bring home something of its spirit: mercurial, both spectral and vivifying, sensual and austere, alive with longing and sated years ago, settling now into the imperturbable sleep of its decline.

CLOTHES *O*ne of the oldest of urban pleasures: to note the variety of costume, the ways of presenting one's body to the world—revealing and concealing, disguising and displaying.

That red, off-the-shoulder gown, first of all, sported by our dreaming friend on the balcony. Ocher skirt, the color of warm terra-cotta. Her tight waist, or the corset beneath it, pushes her breasts up; to modern eyes it's a dress of anticipation, worn to wait for a lover, or at least to dream of one. An art historian informs me that she is probably the maid; I'm not at all sure I believe him, but if he's right, imagine dressing so seductively to clean a house!

The red domino and dashing tricorn of that man being ferried by gondola across the canal. The look of a courtier, something secretive in his errand. A tryst, a dalliance?

Over near the steps of the Salute across the Canal: is that a senator, in voluminous pink gown (probably faded scarlet, since red paint's apt to bleach away) and serious wig?

The workmen in their gray and dun breeches, their blouses and stocking caps (beneath which Bellotto seems to have given many of them the same nose, especially the ones turned in profile). Women walking in head wraps and shawls, sheathed as if they're also trying to be fluid.

CONVERSATIONS Knots of twos and threes—chance encounters, small meetings, animated discussions, casual greetings. The dense human fabric of the city breaks up into these little nodes, the medium of exchange, recombinant social architecture. Citizens in dark robes, leaning toward one another, standing in shadow. Traffic in gossip, actual news, prices, opportunity, social reports, weather, politics, idle talk, recognition, compliments, insult, the occasional idea.

SILENCE On a boat in the middle distance, four men stand apart, all facing in different directions. The lead oarsman looks ahead, as if toward the future, while his fellow stands at the stern, lifting his oar; between them, two passengers, well-dressed men who can afford the fare, face different ways, one toward the pale gray domes of the Salute, one with his head turned as if to suggest his gaze is directed into the water, with its lovely pattern of ripples like a regular network of scales. (Fractal relation, as if water and fish partook of the same patterns.)

BOATS　　　　*T*he infinity of them, in the distance, clustered in the Bacino di San Marco, off along the Riva degli Schiavoni. A welter of vessels, a dense web of rigging, as if Bellotto were playing at seeing how much he could hide, at how much might be discerned in the farthest direction of the horizon. At first a meaningless if intricate jumble—and then it never quite seems to stop revealing more and more. So much to be known! Praise for the instrument of the eye.

MASTS　　　　*A*top the Customs House, kneeling figures balance a big sphere on their backs, and atop the ball Fortune stands, holding a sail. To the right, across the channel obscured by buildings, the dome of Santa Maria Maggiore rises from the island of the Giudecca, but that crowned Palladian bubble has been cut apart by a tracery of rigging, and just to its right is a grand single tower of a mast, and then a realm of masts. These ships are docked nearby, just on the other side of the Dorsoduro, but their spires have become detached from the vessels that carry them so that they've become a carnival array, fantastically detailed, strung with geometries of rope and sail, flying banner upon banner.

Here the artist takes unflagging delight in his work of description. He shows off; he renders a distance so intricate as to seem inexhaustible. So complicated, visually, that finally we simply have to give up and admire him—our eyes can't possibly match his, can barely follow these intricate distances in their overlaps and complexities. Thus he's accomplished what every painter of views must wish for: we're stunned. There's more here than we thought, and more than we'll ever see.

GALLEON *I*t lists, golden and heavy, as if tilting with the weight of plunder. The glory days of Venetian power and trade are long over, by the time Bellotto sketches out his scene, but this ship seems to recall them. Browning: "Venice spent what Venice earned."

STATUES *F*igures ringing the base of the dome of the Salute, as isolate as the people daydreaming on their balconies across the canal: dialogue across several hundred feet of water.

PATINA *S*ilvery, leaden sheen of the domes, roof tiles, aging brick, stone archways. Everything, even then, stained, oxidized, discolored, patinated, shaded, made subtle by the individuating forces of decline. Can this happen to the contemporary city? In America we tear down the old, or polish it into unrecognizability; we make it "historic" and visitable, a replica of itself, metals replated, colors restored. Make it new or cart it away. The jagged iron ribs of the World Trade Center—the most painful, exacting evidence of ruin in 2001—disappear by 2002. Where are they now, those sharp, Gothic pieces, photographed again and again in the long smoke rising from the rubble?

We like our evidence of time at a distance: quaint, pickled in resin or amber. We don't want it near our own bodies.

PATINA (2) *B*ut then I needn't worry: everything's subject to history, and no place proves it like New York City: what was new last year now is sooted, grimed, graffiti'd, postered, inscribed, inhabited. This city is, precisely, layer upon layer of the physical evidence of time, and clean it up as we might, the evidence accumulates; we're brined, scoured, salted, no less than Venice is.

RELIQUARY *I*n the Palazzo Venier dei Leoni, Peggy Guggenheim's serene Venetian temple of modern art, there's a box by Joseph Cornell, who never visited Venice as far as I know but seems nonetheless to have made a work of art which is a redaction and mirror of this city, its essence and catalogue. Like much of Cornell's work it is a wooden box, encased in glass, and in this one rows of glass jars line up on little shelves backed by mirror that allows us to glimpse, behind these strange little vials, fragments of ourselves.

In the jars are scraps: bits of silk and of unreadable text, mineral powders (perhaps pigment for the manufacture of artists' oils?), gold dust, the detritus of making, the hoard of material a rich and powerful city would bring home from all the far-flung world. The stuff it would hammer and weave, tint and shape into glory, its own fiery alchemical work of glorification.

In Cornell's little box—assembled out of the stuff of the junk shops and dime stores of Manhattan—are arrayed the materials out of which the West has made itself, and this vitrine—like Bellotto's painting, like any painting, perhaps—is both shrine and elegy.

*R*uskin: "The long range of columned palaces . . . each with its image cast down, beneath its feet, upon that green pavement which every breeze broke into new fantasies of rich tesselation . . . It was no marvel that the mind should be so deeply entranced by the visionary charm of a scene so beautiful and so strange, as to forget the darker truths of its history. . . . Well might it seem that such a city had owed her existence rather to the rod of the enchanter, than the fear of the fugitive . . . and that all which in nature was wild or merciless—Time and Decay, as well as the waves and the tempests—had been won to adorn her instead of to destroy, and might still spare, for ages to come, that beauty which seemed to have fixed for its throne the sands of the hour-glass as well as of the sea."

*N*early all the buildings in this painting—at least on the two islands in the foreground—still stand, a gift first of the decline of commerce, so that tearing down old for new ceased, and then of the preservative saline of tourism, which pickles and sustains. And so this must be one of the few three-hundred-year-old canvases in the world which one could place exactly in the spot where it was painted and see, in essence, the same space. True, those darkish apartments across the canal, to the right of the Salute, are gone, replaced by a palace; true, Bellotto revised the space a bit, as any good artist does, to enhance his composition. The galleon and thicket of masts are gone, the boats motorized now, save for the tourist gondolas and the occasional small rowboat, and the streets are populated by citizens differently outfitted, only a very few of them Venetian.

Yet it remains the same space. This is a haunting thing: we can align our eyes with Bellotto's; we can physically enter the space of the painting, run our eyes along this same complex set of roof lines, along the complicated figures on the parapet of the Salute, over the still-silver patina of its dome.

This means that Bellotto's painting, in a particularly gripping way, has come to be about *time*. You can't really look at it, especially if you have been to that spot, without layering the present atop the past, your perceptions against the painter's, your eye married to his, your own body positioned, momentarily, in the space he occupied. Chill breath out of time.

In Warsaw, after the devastation of the Second World War, Bellotto's views of the old city were used to aid in its reconstruction. He pointed to the vanished, as if he were seeing it still; the exactitude of his eye stood against the force of history.

MEMORY *B*ecause this picture must inevitably be about time, we are propelled into the Venice of our own: place we have imagined, visited, revisited in dreams, recognized in art, found echoed around the world, in everything from canvases on museum walls to murals in Italian restaurants. The strange shiny replica of a Las Vegas casino, the luxe suburban daydreams of homes built along lagoons in New Jersey and Florida. The expensively boho houses along the dredged canals blocks from the ocean in Venice, California. A pattern, a vocabulary of possibility: city of water, fluid metropolis, the Western city's achieved dream of itself.

ALCHEMY *L*ight water stone become one substance. What is it? A suspended surface, the world's skin.

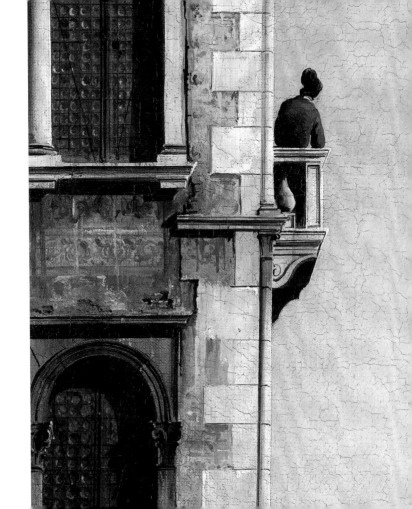

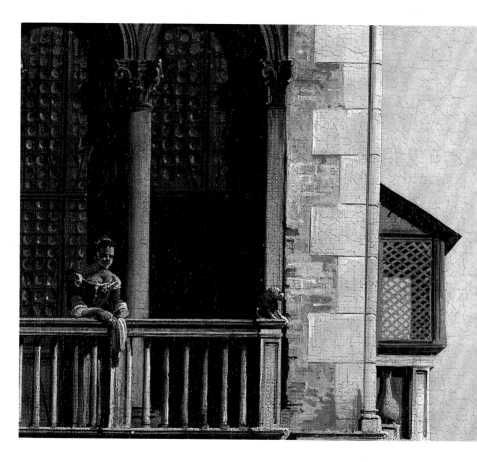

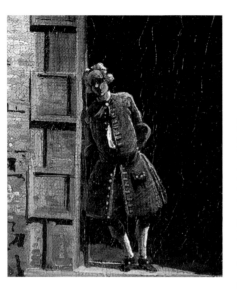

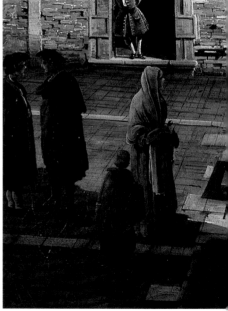

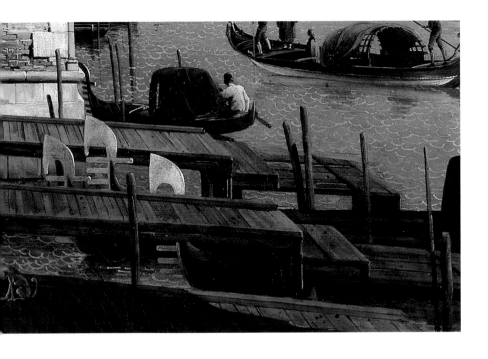

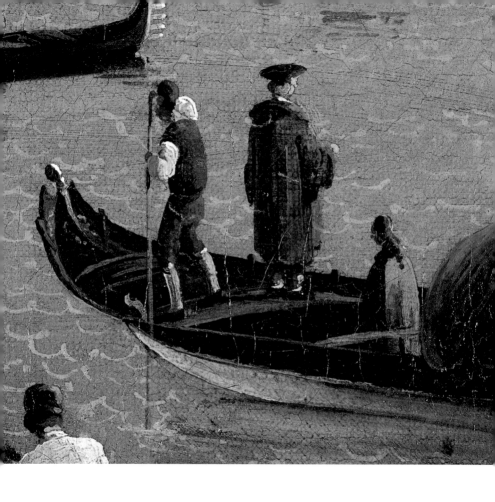

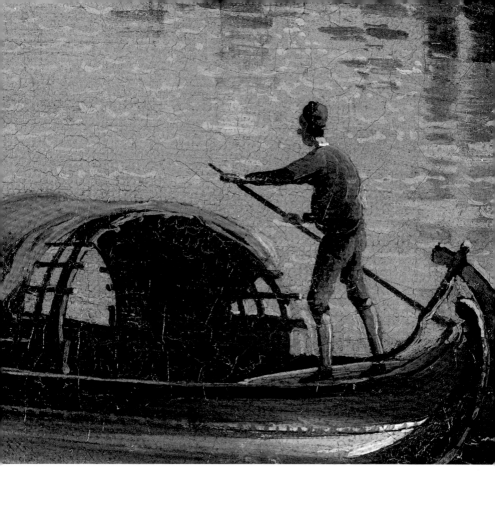

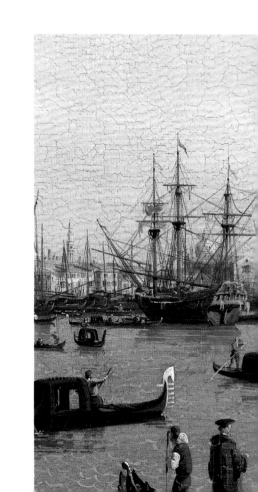

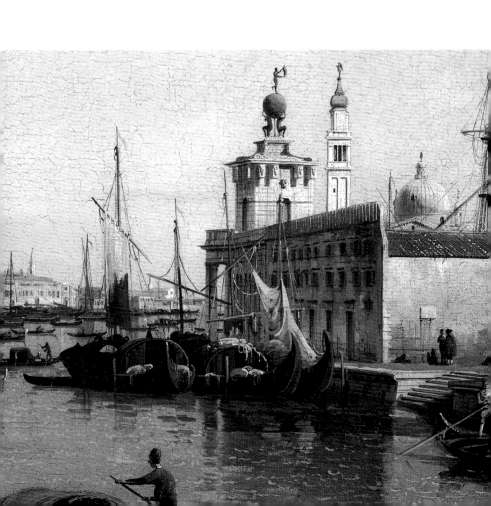

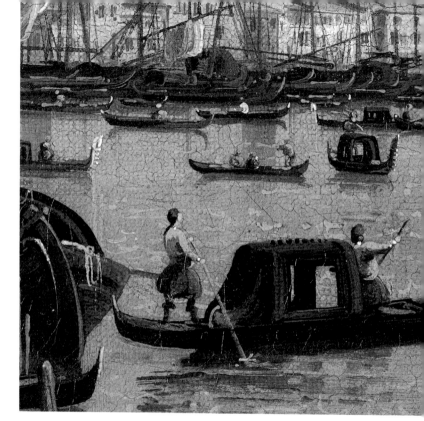

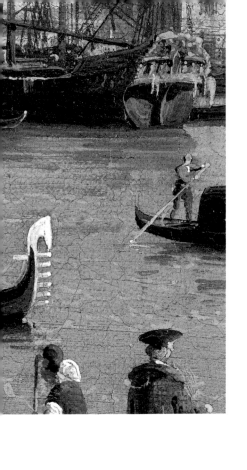

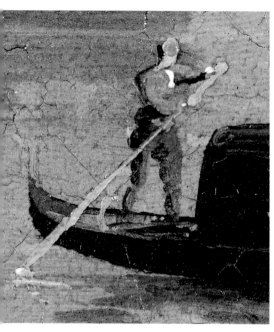

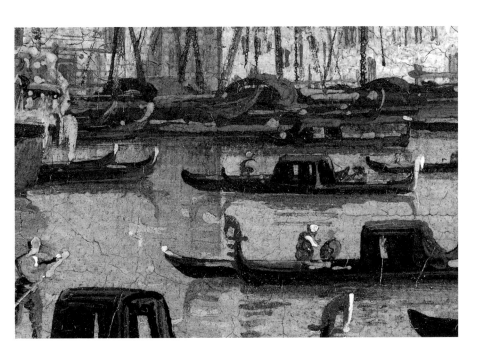

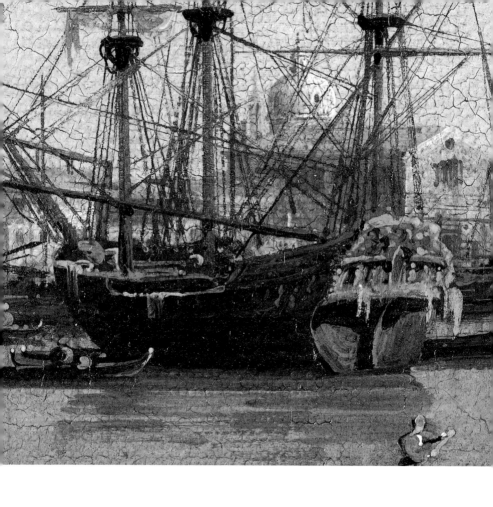

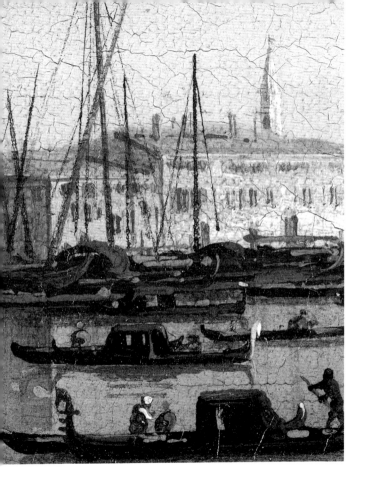

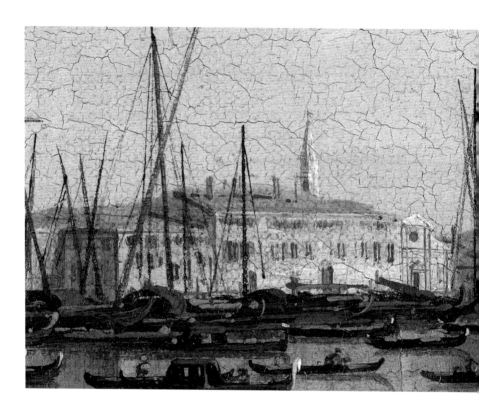

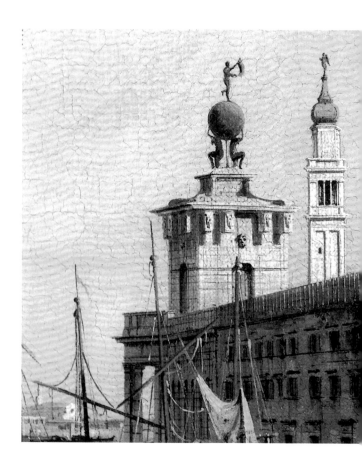

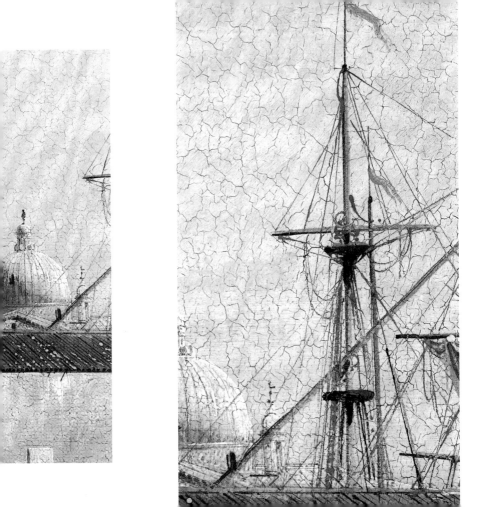

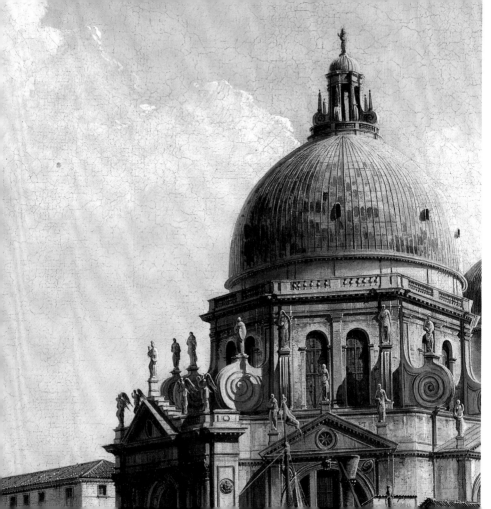

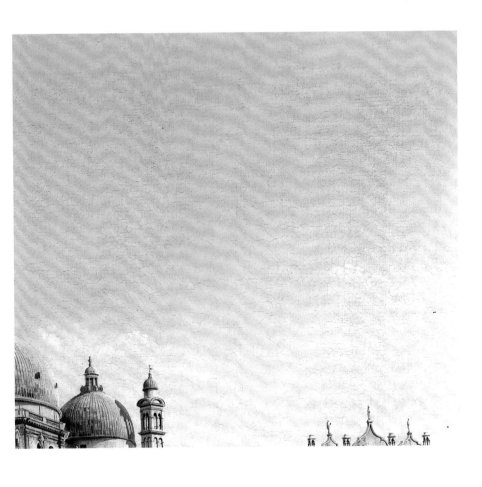

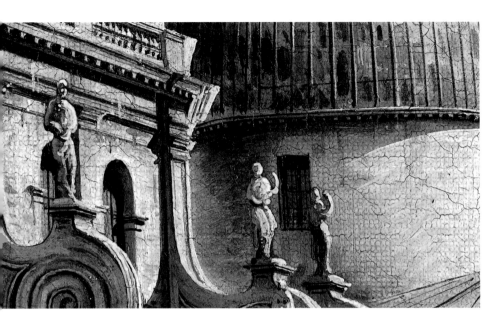

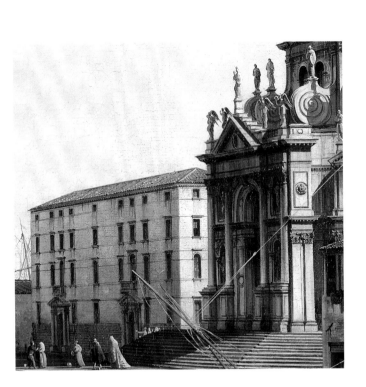

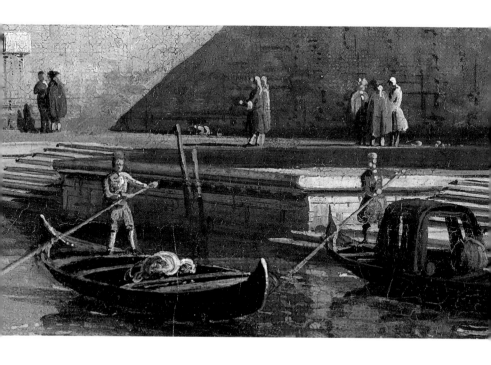

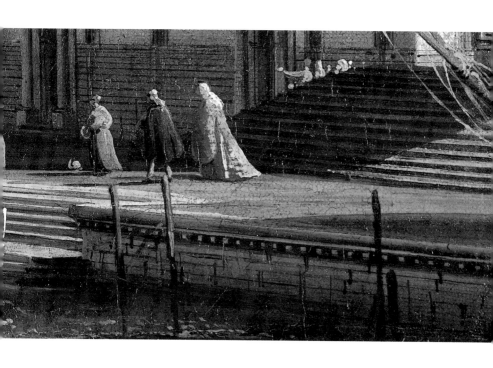

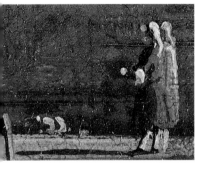

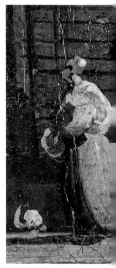

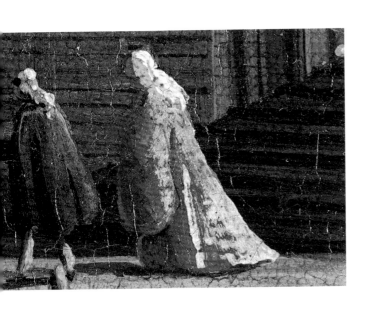

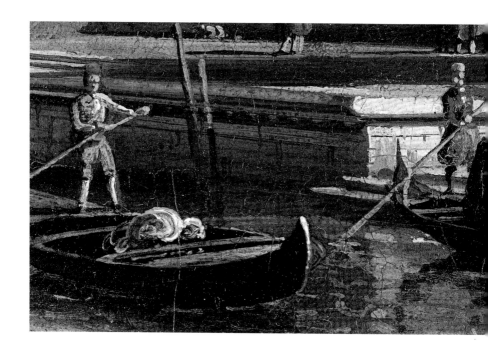

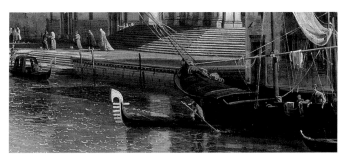

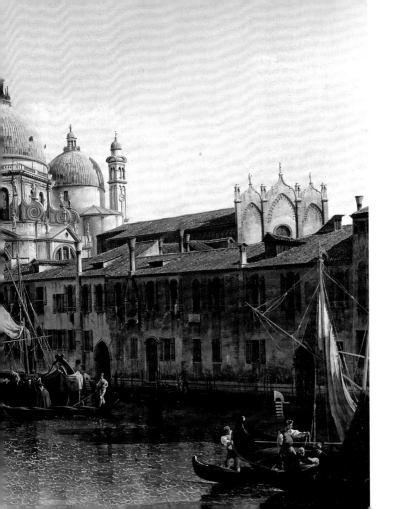

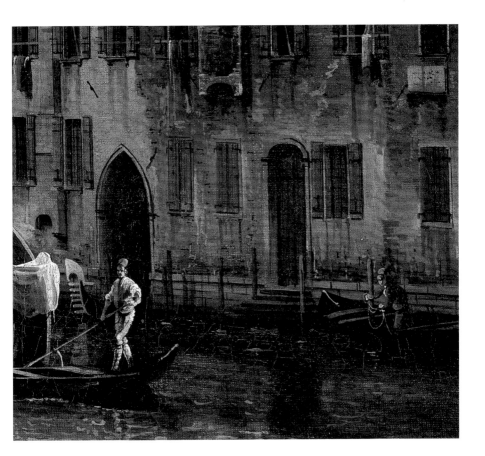

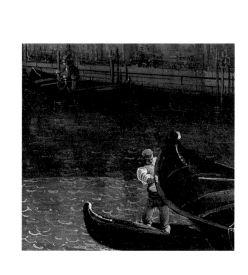

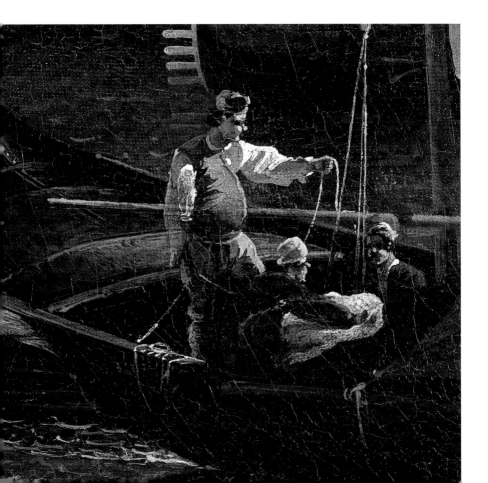

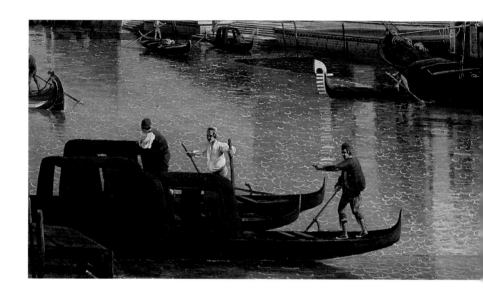

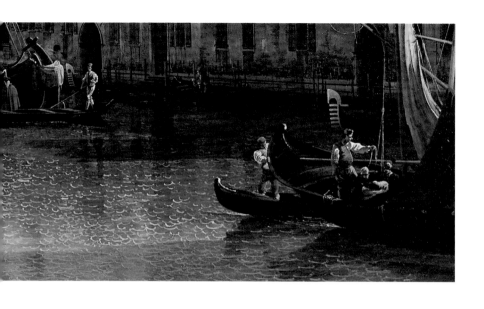

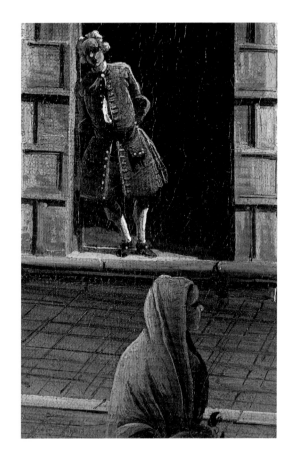

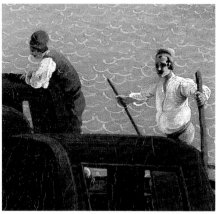

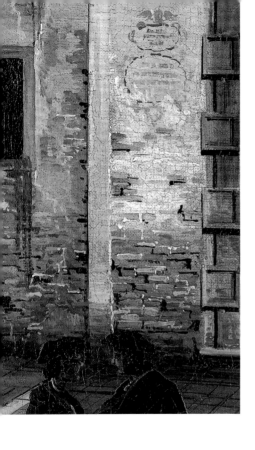

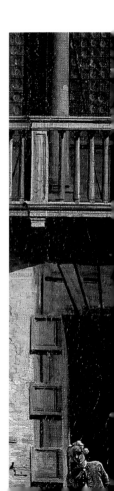

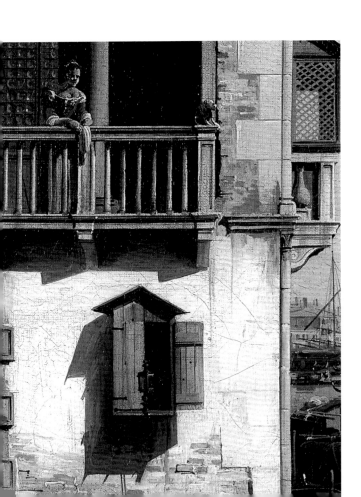

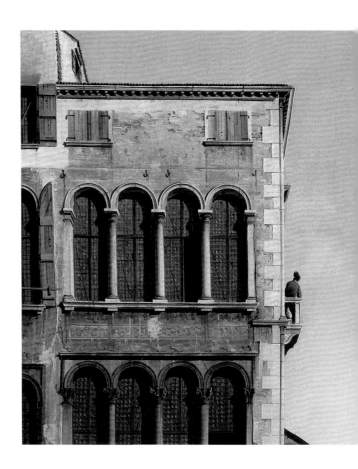

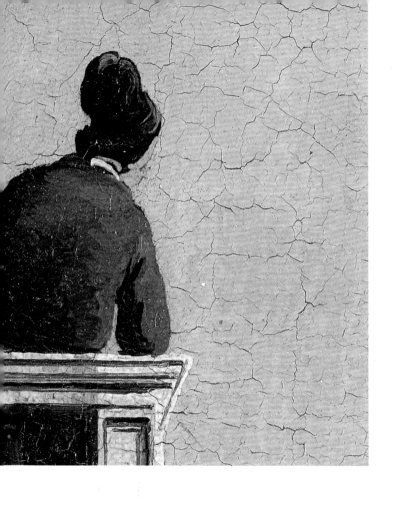